This is
Cézanne

Published in 2015 by
Laurence King Publishing
361–373 City Road
London EC1V 1LR
United Kingdom
T +44 20 7841 6900
F +44 20 7841 6910
enquiries@laurenceking.com
www.laurenceking.com

A catalogue record for this book is available
from the British Library.

ISBN: 978 1 78067 478 0

Series editor: Catherine Ingram

Printed in China

This is
Cézanne

JORELLA ANDREWS
Illustrations by PATRICK VALE

LAURENCE KING PUBLISHING

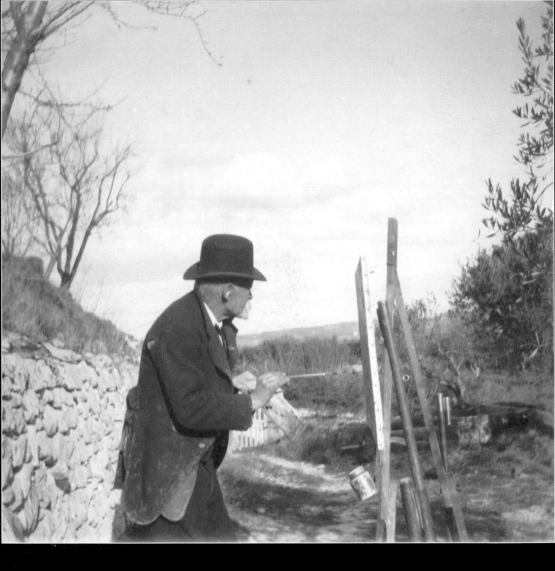

Cézanne painting Mont Sainte-Victoire, 1906

Paul Cézanne is admired as one of the world's greatest artists, not because like Michelangelo, Raphael or Leonardo he perfected a style or tradition, but because he challenged convention and pioneered new possibilities in painting. He depicted aspects of everyday life that most people were too limited in their outlook to perceive. In his mature work he used colour and line in unexpected ways to reveal dynamic yet deeply harmonious visions of the world.

By 1906, when this photograph was taken of the elderly Cézanne painting his beloved Mont Sainte-Victoire in his native Provençal countryside, he had begun to attract a following of adventurous young artists. But most of his career was plagued by rejection, both by critics and the public, who either ridiculed his paintings or were offended by them. In 1884 the middle-aged Cézanne declared that Paris – the centre of the nineteenth-century art world – had defeated him.

Although Cézanne craved approval from the fashionable metropolis, Paris was neither the scene nor subject of his experiments and discoveries in painting. His originality and modernity were cultivated in rural France, where he chose to live most of his life, often alone. He has often been seen – with some justification – as a tormented, reclusive genius. Nevertheless, his creative progression was strengthened by relationships with family and friends, artists and collectors, and he developed working conditions that minimized the frustrations of his artistic life and focused his extraordinary vision.

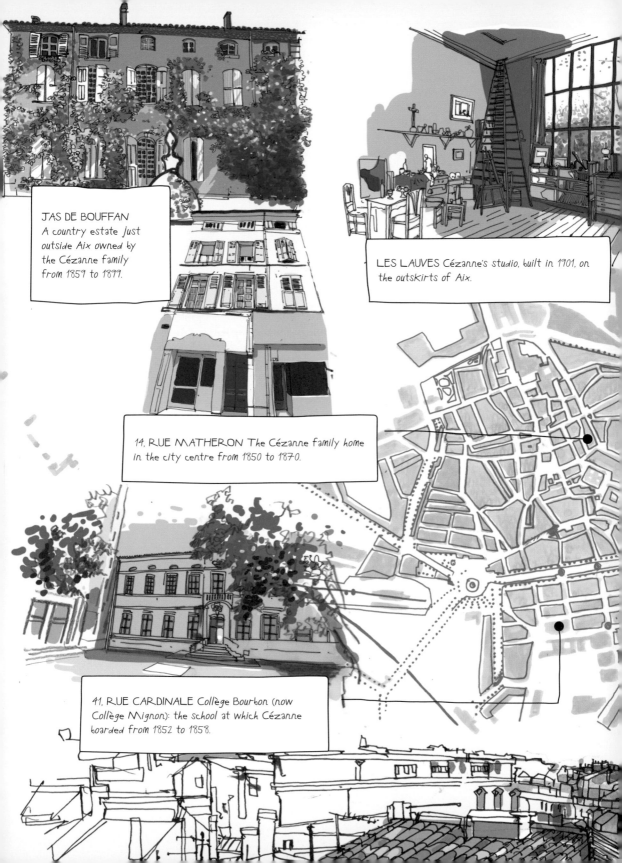

JAS DE BOUFFAN
A country estate just outside Aix owned by the Cézanne family from 1859 to 1899.

LES LAUVES Cézanne's studio, built in 1901, on the outskirts of Aix.

14, RUE MATHERON The Cézanne family home in the city centre from 1850 to 1870.

41, RUE CARDINALE Collège Bourbon (now Collège Mignon): the school at which Cézanne boarded from 1852 to 1858.

Cézanne's Aix-en-Provence

28, RUE DE L'OPÉRA Cézanne was born here on 19 January 1839.

MONT SAINTE-VICTOIRE and the BIBÉMUS QUARRIES Local landmarks to the east of Aix, much loved and painted by Cézanne.

PLACE SAINT JEAN DE MALTE The Aix Museum (now the Musée Granet): this building contained the free municipal school of drawing where, from 1857 to 1862, Cézanne first took art classes.

Childhood in Aix

Paul Cézanne was born in the city of Aix on 19 January 1839, out of wedlock, to parents who became increasingly prosperous. His father, Louis-Auguste Cézanne, then aged 40, ran a business manufacturing and importing hats; Paul's much younger mother, Anne-Élisabeth-Honorine Aubert, had once worked there. The couple were officially married five years later and in 1848 Louis-Auguste, with a business partner, established a very profitable bank. Paul was the first of three children: Marie was born in 1841, followed 13 years later by Rose. Paul, being his ambitious father's only son, spent much of his life battling with paternal expectations that did not match his own.

But Paul's youth was a happy one. Lively and intelligent, though somewhat temperamental, he was a prize-winning student with strong friendships. Closest to him was the young Émile Zola, whom he defended from bullies when they became fellow pupils at the Collège Bourbon in 1852. Cézanne, Zola and a third friend, Baptistin Baille – later a distinguished professor of optics and acoustics in Paris – spent memorable hours sharing their passions for nature and art, poetry, ideas and experimentation.

Dreams

Known at school as 'the Inseparables', Cézanne and his two friends shared intellectual and poetic ideals and together they mapped out their creative ambitions, inspired by the possibilities and challenges of the times. In France, socialist and anarchist ideals were shaping the political landscape and fast-paced technological change and urbanization were affecting the whole of society. Mainly through reading books and magazines – including *L'Artiste*, to which Cézanne's mother subscribed – they were passionately drawn to artists and authors from both the Romantic and the realist movements who were sensitive to these changes and making an impact.

Romanticism – whether in the art of Eugène Delacroix and Théodore Géricault or the novels of Victor Hugo and Alfred de Musset, which the friends devoured – had been defying the rationalist ideals of the Enlightenment since the early part of the century. And in mid-century, the anti-establishment, realist painter Gustave Courbet was disturbing the status quo with monumental works that made heroes of ordinary working people. There were also the realist writers of the first half of the century, such as Stendhal, Honoré de Balzac and Gustave Flaubert, in whose literary footsteps Zola would follow. Zola thought that his friend Cézanne might become a poet. But, if there was no evidence of the painter he would become, the appetite was there: in 1857 Cézanne began to attend evening courses at Aix's free municipal school of drawing. He produced life drawings and copied plaster casts of ancient sculpture and marble originals housed in the museum attached to the school.

But in February 1858 everything changed. Zola moved to Paris, leaving Cézanne and Baille bereft. The following December, a depressed Cézanne, craving Paris and art but pressured by his father to pursue a profession, registered to study law at the University of Aix. 'Law, horrible Law of twisted circumlocutions', he wrote to Zola.

'When the three of us met at the beginning of our lives and – urged by an unknown force – seized each other by the hand and swore never to separate, not one of us enquired about the wealth and possessions of his new friends. What ... we were looking for was ... the value of heart and mind and most of all that future which our youth dangled so attractively in front of our eyes.'

Zola to Baille, 1860

Louis-Auguste moves up in the world

By 1859 Louis-Auguste's bank had gone from strength to strength (owing to its focus on short-term moneylending) and in September he was able to buy an eighteenth-century mansion on the western outskirts of Aix. In fact Louis-Auguste obtained the property from one of his debtors, who presumably would not otherwise have been able to repay him. The Jas de Bouffan – which literally means 'habitation of the winds' but may refer, less poetically, to a seventeenth-century *jas*, or sheepfold, that had stood on the site belonging to a Monsieur Bouffan – was in rather poor repair. Louis-Auguste therefore retained the family home in Aix as the family's principal residence until about 1870.

Paul was now 20, still studying law and still longing for Paris. Nevertheless he quickly came to love the country home, even though he would habitually refer to it as his father's house. Over the next decades the Jas de Bouffan and its extensive estate would become a frequent subject of his painting and drawing.

The Jas de Bouffan was set in 14 hectares (almost 35 acres) of grounds where, especially from the 1870s onwards, Cézanne would experiment with landscape painting outdoors.

Louis-Auguste converted an upstairs bedroom into a studio for Paul in the 1880s.

The family's main living room on the first floor was the setting of several of Cézanne's portraits of family and friends.

During the 1860s Cézanne's father allowed him to paint murals in the large, unused salon on the ground floor.

Early works

While studying law Cézanne kept up with his art classes. Most
of his artworks from this period have not survived, including
a series of landscapes painted in the winter of 1860–61. He, or
possibly his father, may have destroyed them. Some early life
drawings remain, as do sketches and caricatures embellishing
letters sent to Zola and other friends. But indicative of Cézanne's
growing frustrations, and abrasive wit, was a series of murals
he executed in the Jas de Bouffan's ground-floor salon between
1859 and 1860. Taking as their subject 'the four seasons', these
awkwardly executed, classically themed panels were pointedly
dated 1811 and signed 'Ingres', after the much revered neo-
classical artist Jean-Auguste-Dominique Ingres, some of whose
work was in the Aix Museum. Cézanne would later describe
Ingres's linear style as soulless, and it seems likely that the murals
are in part an elaborate satire on Ingres. Certainly the murals
differ dramatically from the wild and expressively brushed
works he would produce during the 1860s (see page 19). In 1865
Cézanne created as a centrepiece for these panels a portrait of
his seated father reading a newspaper, painted in bold impasto.
The colour scheme is extraordinary: layers of muted earth
colours contrast with a bright expanse of terracotta floor tiles.

Paternal conflict

Cézanne complained that his father was domineering and did not understand his son's creative inclinations. But Louis-Auguste gave his son fairly free artistic rein within the Jas de Bouffan and even posed for him on several occasions. Whether this was just to placate and entice his son into the family business is uncertain, but Cézanne clearly couldn't bear the prospect of a career in the law or banking. He was well aware, however, that his pursuit of art would require financial backing from his father, who evidently doubted the wisdom of such an investment. Although in 1859 Cézanne won the drawing school's second prize for painting, his teacher advised against his pupil's much-desired departure for Paris. Instead Cézanne's former classmate Philippe Solari was the next to leave for Paris, where he trained as a sculptor.

In May 1860 Zola wrote urging Cézanne to be strong:

> It needs therefore some little effort, old boy, some persistence. *Que diable*, have we completely lost all courage? After the night will follow the dawn; let's try, therefore, to survive this night as best we may, so that, when day breaks, you can say: 'Father, I have slept long enough, I feel strong and courageous. Take pity? Do not lock me up in an office; give me my wings, I suffocate, be generous father ….'

The pull of Paris

During the 1860s Paris – the centre of the art world – was being modernized. Straight, wide boulevards and glamorous shopping arcades, department stores, great parks and huge exhibition sites were being constructed, and the city was transforming into what many regarded as a man-made paradise. Its cafés and parks were favourite meeting-places for discussion, debate and drawing, as was the Académie Suisse, a training-ground for artists excluded from the École.

The bastion of academic art was the École des Beaux-Arts. It opened the door to professional acclaim and the best chance of commissions and sales, but at a cost – you had to follow its rules. Artists who trained here often established studios of their own, attracting students who had been denied entry to the École. The public showcase of the École was its great annual exhibition, the Salon. Any artist could submit work but the rejection rate was high.

Paris was a magnet for artists who didn't want to follow the rules, in particular those who later became the Impressionists. During his first decade in Paris, Cézanne met and mixed with all the key figures of that group, including Manet, Monet, Renoir, Sisley, Degas and Pissarro. During the 1860s they all struggled together to be accepted in the Salon but continually had their submissions rejected.

Paris life

In April 1861 the 22-year-old Cézanne arrived in Paris. Louis-Auguste had been worn down not only by his son's constant complaining, but also because his wife and his daughter Marie ultimately sided with Paul as well. Louis-Auguste, who had lived in Paris himself as a young man, escorted Cézanne and stayed a month to see him settled. Marie came too.

Foremost among those awaiting Cézanne was Zola, who rapidly established himself in the 1860s as an art and literary critic. Zola was exhilarated at being reunited with his old friend, though by June he reported seeing less of Cézanne than he'd expected, and during the 1860s their relationship started to show signs of strain.

Following an itinerary for study proposed by Zola, Cézanne spent most of his mornings at the Académie Suisse, housed in a run-down residence on the Île de la Cité. Its curriculum stressed life drawing, albeit without formal instruction – rather, the pupils learned from each other. By the time Cézanne arrived, many of the artists making up Paris's avant-garde had passed through its doors, including Manet, Monet and Honoré Daumier. There, Cézanne befriended another Aixois painter, Achille Empéraire, along with Antoine Guillemet and Camille Pissarro. Cézanne's efforts at the Académie were a source of (probably) good-humoured amusement for the other students. Sensitive and short-tempered, he was soon nicknamed '*l'écorché*' – 'the flayed man'.

Paris–Aix, Aix–Paris ...

In the autumn of 1861, having worked long hours at the Académie Suisse and spent afternoons painting in an older artist's studio, Cézanne tried to gain entrance to the École des Beaux-Arts. He was refused. This defeat was quickly followed by a return to Aix. His father, greatly relieved, offered him a position in his bank.

Cézanne was not entirely unhappy to return to Aix. He seems to have found Paris difficult to stomach, complaining to a friend in Aix that, although he was 'out and about almost all day long', he felt bored. Nevertheless, a year later he was back and this time he stayed true to his artistic goals, despite probably having been rejected once more by the École.

From November 1862 to September 1870 Cézanne lived mainly in Paris, supported throughout – it is relevant to note – by a small allowance from his father. But he also made frequent visits to Aix, usually lasting several months at a time, where he could live more comfortably at his parents' home while continuing to paint. This makes it difficult to keep track of his whereabouts at any given time, but we do know that he re-registered at the Académie Suisse in 1862, where he continued to work regularly throughout the 1860s. In 1863 he obtained authorization to make copies of paintings in the Louvre, a practice he would continue throughout his life. Each year, probably until 1886, he and his avant-garde artist friends would submit work to the Salon, to no avail.

A dark romanticism

The youthful Cézanne took an original, and what he would later call a '*couillarde*' or 'ballsy', approach to painting. (It is not entirely clear whether or not his older self meant this as a compliment to his younger self.) He applied thick oil pigment to canvas with a palette knife – a technique he had adopted from Courbet – to produce work that had darkly hued, expressive, sculpted surfaces. This characteristically impassioned style came to fruition in later portraits of the 1860s, including those of his uncle Dominique, his father, sister and mother (see pages 27 and 28). He also used it in bold still lifes and the disturbing, often erotic paintings he produced from 1867 into the 1870s, with titles such as *The Rape*, *The Orgy* and *The Murder*. The themes suggested by these titles – also tackled by Zola in his 1867 novel *Thérèse Raquin* (in which a young wife and her lover murder her husband) – were inspired by the classical sources he had studied as a boy. Commentators have regarded these paintings as psychological portraits of the artist, indicating problems of rage and sexual repression, and, admittedly, several of them contain apparent self-portraits. Certainly, the expression of deep feeling was always fundamental to his art-making.

During the 1860s Cézanne's approach contrasted with that of academic painters, including the internationally renowned William Bouguereau and Alexandre Cabanel, whose mythological painting *The Birth of Venus* was lauded at the Salon of 1863. The style and energy of Cézanne's work also differed significantly from that of his avant-garde contemporaries, who were increasingly drawn to explorations of light and depictions of modern, urban life, and were deriving different lessons from Courbet and the Barbizon School. With the exception of Zola and Manet, it seems that most of Cézanne's avant-garde peers found his work perplexing.

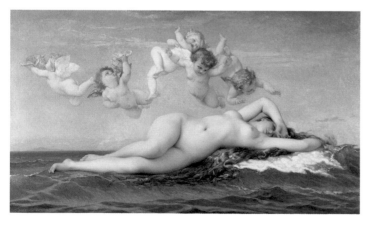

Alexandre Cabanel
The Birth of Venus, 1863
Oil on canvas
130 × 225 cm (51³⁄₁₆ × 88⁹⁄₁₆ in)
Musée d'Orsay, Paris

Building a bad reputation

Cézanne's expressive and unusual art-making during the 1860s may reveal elements of his personality in this period of his life. We know from Zola and Baille that, even as a boy, Cézanne was prone to fits of temper, but – as Zola wrote to Baille just before Cézanne's arrival in Paris – they also recognized one 'whose character is so good, so open, whose soul is so affectionate, so gently poetic'.

In both Paris and Aix Cézanne fashioned himself as an *enfant terrible*. In Aix he alarmed residents with his unconventional attire, while in Paris he exaggerated his Provençal identity, playing the country bumpkin. He became known for his unkempt appearance, his uncouthness and his sudden sharp, witty and often offensive observations. He railed against the artistic and intellectual establishment: they were 'Bozards' (from Beaux-arts), 'bastards', 'eunuchs' and 'jackasses'. In 1863 two of his works were included in the famed Salon des Refusés, which had been set up that year to display to the public a record number of rejected Salon submissions.

Even at this early stage a 'fictional', anecdotal version of Cézanne – recognizable in the writing of Zola and others – was beginning to circulate, so much so that it quickly became difficult to untangle biographical fact from invention. In his 1872 story 'The Painter Louis Martin', for instance, Edmond Duranty wrote that, 'The painter – bald, with a huge beard and protruding front teeth, looking at once old and young … was sordid, indescribable. He gave me a bow, accompanied by an inscrutable smile, either mocking or stupid.'

An artistic temperament

The idea of temperament as a test of character and as a creative force was important for Cézanne. 'Only original capacity, that is, temperament, can carry someone to the objective he should attain,' he declared. Towards the end of his life he stated, 'With only a little temperament one can be a lot of painter.' Likewise Zola, who was formulating a theory of art in the 1860s, famously defined a work of art as 'a corner of nature seen through a temperament'. Of broad influence here were the philosophical ideas and pre-psychoanalytic explorations of character proposed by Hippolyte Taine, professor of Art History at the École des Beaux-Arts from 1864 to 1884. Rejecting the popular, but indefinable, idea of the great artist as genius, he claimed that, 'A work of art is determined by an aggregate which is the general state of the mind and surrounding environment.' Taine's lectures, later published in his *The Philosophy of Art*, supported the development of naturalism and realism in art, that is, the growing orientation towards landscape painting, and scenes and subjects testifying to the realities – and often the hardships – of everyday life.

Taine also wrote that, 'A certain moral temperature is needed for certain talents to develop; in its absence, they fail.' He was in addition a source, perhaps *the* source, for another increasingly central guiding principle for Cézanne, that of 'sensation'. At issue here was not sensationalism, but sensitivity to sensory impressions and to what Taine had described as the essential character of the thing perceived and experienced. For Cézanne, the artistic search 'for the motif', conducted out of doors with the artist immersed within the scene being depicted, was important. It enabled him to transcribe a receptive and personal perception of the world directly onto the canvas.

In April 1866, while visiting Guillemet, Manet had seen and admired some of Cézanne's still-life paintings. Cézanne admired Manet too. But when they met in the Café Guerbois in September of that year, Cézanne's response was characteristically contrary: 'I won't give you my hand, Monsieur Manet, I haven't washed for eight days.'

A rebel, learning from the Louvre

From early on Cézanne declared himself a rebel and made work that shocked respectable sensibilities. But despite carving out a strongly independent path, he frequented art galleries, especially the Louvre, and spent many hours copying from the old masters. He would continue to do so throughout his life.

For Cézanne and his avant-garde contemporaries, copying from the old masters opened up a wide range of artistic traditions and possibilities that the rule-bound taste of nineteenth-century academic art had closed down. Here they learned how to work convincingly with line and colour and create dramatic visual statements. Manet, for instance, was inspired by the High Renaissance Venetian painter Giorgione's work in the Louvre.

Cézanne had broad tastes. In the 1860s he particularly admired Delacroix – who had painted the ceiling in the Louvre's Galerie d'Apollon – for his emotionalism and expressive brushwork. The seventeenth-century Spanish masters – painters such as Francisco de Zurbarán and Jusepe de Ribera – were also crucial to his artistic development. With their intense, strongly structured yet carefully balanced and illuminated compositions, they provided inspiration for his early still-life paintings. Manet, too, was influenced by the Spanish School. In Cézanne's mature period, Michelangelo and painters working in the colourist tradition (sixteenth-century Venetians Jacopo Tintoretto and Paolo Veronese, and the Baroque painter Peter-Paul Rubens) were important. Surprisingly perhaps, even during his expressionistic years Cézanne was drawn to the seventeenth-century classical painter Nicolas Poussin's work. In April 1864 he is known to have copied one of Poussin's paintings and many of Cézanne's later landscapes would be modelled after Poussin's harmonious compositions.

Cézanne often also studied the old masters from reproductions – in periodicals such as *L'Artiste*, already mentioned, and *Magasin pittoresque* – and in *L'Histoire des peintres de toutes les écoles* by the academician Charles Blanc and others, which had been published in instalments since 1849.

At the end of his life, Cézanne described the Louvre, that great public showcase of European art, as 'the book by which we learn to read'. He also maintained that we must not, however, 'be satisfied with retaining the beautiful formulas of our illustrious predecessors'. A great many artists studied in the Louvre – in 1872 the writer Duranty described it as 'a forest of easels and ladders'. Importantly, in an age when it was difficult for women to become artists, female painters were also permitted to work here. These women included Mary Cassatt, who arrived in Paris from America in 1866, and the leading French female Impressionist, Berthe Morisot.

A fruitful stay in Aix

One of Cézanne's extended periods in Aix occurred during the autumn and winter of 1866. 'I'm back among my family, the foulest people on earth,' he wrote to Pissarro, 'those who make up my family, excruciatingly annoying. Let's say no more about it.' Harsh words! Yes, on the one hand Cézanne was deeply frustrated and discouraged by his family's lack of interest in and understanding of his art, but on the other hand his father did provide ongoing financial support despite that lack of interest and there was always a place within the family home for him. Nonetheless, the work he produced during these months was significant. 1866 would be a landmark year in the story of Cézanne's artistic development.

Of especial interest are his family portraits. His most willing model was Dominique Aubert, his mother's brother. Cézanne made several studies of Dominique's facial features, but also made him pose in a variety of costumes: wearing a turban, dressed as a monk or as a lawyer, speaking and gesticulating in full flow as if in the court room. All the works were painted in thick, energetic, but also fluid and fluent, palette-knife impasto. According to Cézanne's friend, the writer and critic Antony Valabrègue – also spending time in Aix and reporting back to Zola – Cézanne completed each of these rapidly, in no more than an afternoon. Cézanne had, incidentally, produced a portrait of Valabrègue earlier that year in Paris which he had submitted to the Salon, defiantly, we are told, with the expectation that it would be rejected. According to Valabrègue, Cézanne was 'a horrible painter as regards the poses he gives people … Every time he paints one of his friends, it seems as though he were revenging himself on him for some hidden injury.'

Another portrait of his father

Cézanne's best-known portrait from this period is of his father.
Once again Louis-Auguste is seated, but this time in an armchair
with floral patterning, known to be part of the Jas de Bouffan's
furnishings. Again he is absorbed in reading a newspaper.
But although his body, legs crossed, is folded into itself, it is
nonetheless somewhat orientated towards that of his painter
son (unlike the chair itself, which is positioned at a diagonal to
the picture plane). On the wall above his father's head Cézanne
depicted his small still life *Sugar Bowl, Pears and Blue Cup* of
1865–66.

One of the talking points of this painting is Cézanne's substitution
of the newspaper his staunch republican father would actually
have been reading, *Le Siècle*, with the liberal newspaper
L'Événement, for which Zola was then writing virulent art
criticism under his pseudonym 'Claude' – these attacks on the
art establishment were causing tension between Zola and the
newspaper's editor. As such, this painting in fact pays homage to
the artistic values shared by Cézanne and Zola. Louis-Auguste
once more finds himself lined up against his son, and against his
son's troublesome friend.

Years later, in 1882, this may have been the portrait that
constituted Cézanne's first and last successful submission to the
Salon, through the intervention of his friend Guillemet (who since
the Académie Suisse, and though younger than Cézanne, was
now enjoying success as a painter). Rather gallingly perhaps,
he did not submit it under his own name but instead as 'a pupil
of Guillemet'.

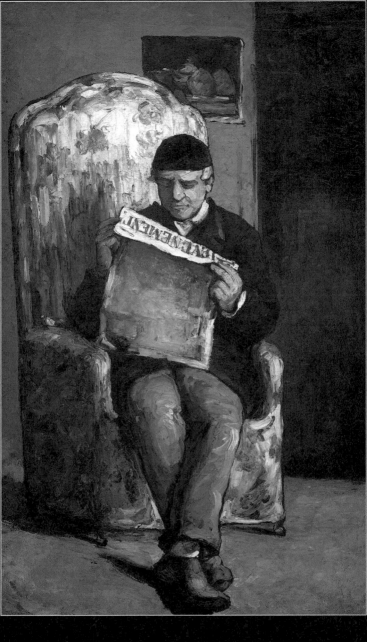

The Artist's Father Reading 'L'Événement'
Paul Cézanne, 1866

Oil on canvas
198.5 × 119.3 cm (78⅛ × 46¹⁵⁄₁₆ in)
National Gallery of Art, Washington, D.C.
Collection of Mr and Mrs Paul Mellon, 1970.5.1

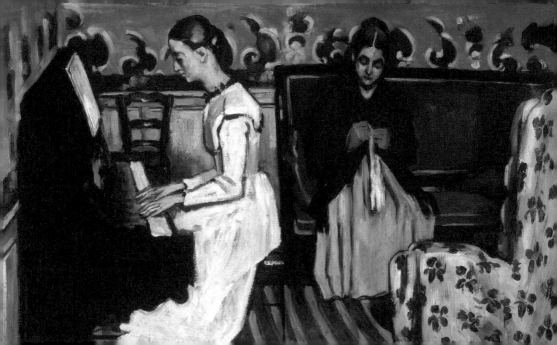

The women in his life

During his 1866 stay in Aix, Paul painted portraits of his mother and sister Marie. About two years later, he painted a larger domestic scene entitled *Girl at the Piano (The Overture to Tannhäuser)*, which some scholars take to be a group portrait of Cézanne's mother and sister (possibly Marie but more likely Rose). Others think the girl is one of his uncle Dominique's daughters but, judging by the wallpaper, the setting is the Jas de Bouffan. The floral armchair in which Cézanne had painted his father is visible in the lower right-hand corner and we know that Louis-Auguste was included in earlier versions of this painting.

There is an incompatibility between the work's title – it refers to Wagner's great opera *Tannhäuser* of 1845, described by the critic Charles Baudelaire as 'voluptuous and orgiastic' when it was staged in Paris in 1861 – and the pensive, introverted bearing of the women. Perhaps this reflects their willingness to engage with a new art form and yet their inability to truly appreciate its significance. (Where his mother and sister were concerned, their support of Cézanne did not extend to a fondness for his paintings. It appears that Marie later kept the pictures Cézanne had given her well and truly hidden.) Perhaps Cézanne was also transmitting a suppressed erotic secret: in 1869, while in Paris, he had begun a liaison with a young seamstress and artists' model, Hortense Fiquet. He was determined to keep this fact from his family. He feared that his father would disapprove and cut off his desperately needed allowance.

Surprisingly, during this period Cézanne also produced a set of paintings drawn from fashion plates found in popular magazines. But perhaps this offered him an attractively stress-free way of depicting the female form – reputedly he experienced high levels of anxiety when faced with female models in the flesh.

'You know, all the paintings done indoors, in the studio, will never be as good as things done outdoors.'
Cézanne to Zola, 1866

1866 was the year that Cézanne turned to landscape painting outdoors, *sur le motif* or *en plein air*. How many he produced during this period is unclear – as noted earlier, some may have been destroyed – but reputedly his first attempt was early that year, at Bennecourt on the Seine, near Paris. Now, in Aix, he embarked on a number of excursions into the countryside with Valabrègue and another friend, Antoine Fortuné Marion. One such trip was memorialized in a painting about which Valabrègue wrote to Zola, 'We are arm in arm and have hideous shapes.' Marion, an amateur painter, was also a Darwinist, geologist and palaeontologist who made his reputation – in 1866, in fact – when he discovered a neolithic cave settlement near the western slopes of Mont Sainte-Victoire.

Cézanne's own connection with the land was powerfully portrayed in a new mural painted on one of the Jas de Bouffan's salon walls: his *Bather and Rocks* of 1860–66. Originally part of a larger landscape, and admittedly inspired by a painting by Courbet from 1853, the section that remains shows a male bather, naked, seen from behind. He stands before a rock face with both hands pressed against its craggy surface. Cézanne himself had a lifelong love of swimming – the 'bather' theme would be much repeated – but this image might also be seen as a psychological self-portrait of an artist experiencing a new desire to use his eyes and hands to penetrate the structure of things.

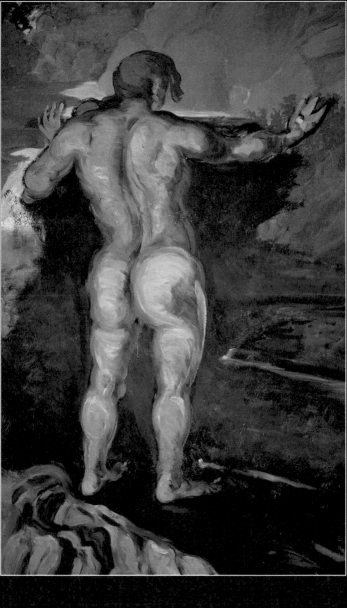

Bather and Rocks
Paul Cézanne, 1860–66

Oil on canvas, transferred from plaster
167.6 × 105.4 cm (66 × 41½ in)
Chrysler Museum of Art, Norfolk, Virginia
Gift of Walter P. Chrysler, Jr.

A Parisian talking point

Early in 1866 Cézanne had supported the avant-garde cause by writing letters of protest to the minister of Fine Arts, petitioning that the Salon des Refusés be reinstated, while Zola published an open letter in *L'Événement* called 'A Suicide', which pressed home the same point. Their campaign was ignored.

Four years later, in the spring of 1870, Cézanne and his latest rejected Salon submission became the subject of a widely circulated caricature in the Parisian weekly *Album Stock*. The caricature shows a reclining nude (most likely later destroyed by Cézanne or his father) and Cézanne's monumental 1868 portrait of his friend Empéraire, who suffered from dwarfism, seated like a king on a throne (in that same floral armchair at the Jas de Bouffan). The ironic, even mocking, text accompanying the caricature – which may have pleased Cézanne but would surely have annoyed his avant-garde contemporaries – read as follows:

> The artists and critics who happened to be at the Palais de l'Industrie on March 20, the last day for the submission of paintings, will remember the ovation given to two works of a new kind … Courbet, Manet, Monet, and all of you who paint with a knife, a brush, a broom or any other instrument, you are out-distanced! I have the honour to introduce you to your master: M. Cézannes [*sic*]. … He is a realist painter and, what is more, a convinced one. Listen to him rather, telling me with a pronounced Provençal accent: 'Yes, my dear Sir, I paint as I see, as I feel – and I have very strong sensations. The others, too, feel and see as I do, but they don't dare … they produce Salon pictures … I do dare, Sir, I do dare … I have the courage of my opinions – and he laughs best who laughs last.'

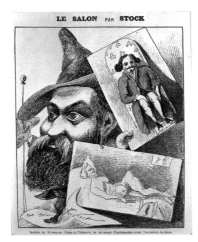

'Le Salon par Stock'
Caricature from *Album Stock*, 1870

Escape to L'Estaque

In July 1870 the Franco-Prussian War broke out. It was instigated by the French emperor Napoleon III, who expected a quick win. Instead, within months his empire had fallen, the Prussian army had invaded France and besieged Paris. A new republican government was established, the Prussians were paid off and withdrew and the short-lived Paris Commune (a socialist coup supplanting the new government in Paris) was first violently established, then crushed. Cézanne, who was in Paris when war was declared, ignored a call for all men of fighting age to enlist in the imperial army and made his escape south to the fishing village of L'Estaque, near Marseilles. Like many others, Cézanne did not support the imperial government and he was actively pursued by the authorities up to the collapse of their government in September. However, the war and its aftermath were confined to the north, particularly around Paris, and did not really reach far into central France, much less the south and L'Estaque. Cézanne probably lived in a small, rented home belonging to his mother. Once in situ he arranged for Hortense to join him. In this peaceful spot Cézanne's work underwent a shift in sensibility, with a focus on landscape paintings that conveyed a new feeling of quietude and sensitive, observational detail.

In September 1870, in the post-war Aix of the new Third Republic, Cézanne's republican-sympathizing father (who had retired and dissolved his banking partnership earlier that year) was elected to the Aix council but, owing to his advancing years, rarely attended. Interestingly Cézanne himself, in absentia, was elected to the council of the Aix drawing school.

The influence of Impressionism

The period after the war was especially important in the evolution of Cézanne's style. In the summer of 1871, after the dust settled, Cézanne returned to Paris with Hortense, and on 4 January 1872 Hortense gave birth to a son. Like Cézanne, young Paul was illegitimate but acknowledged by his father at birth. Except for Cézanne's decision to keep his young family a secret from his parents and sisters, family history was repeating itself. Empéraire paid a visit, reporting that Cézanne was hard up – he was trying to support a family of three on a small allowance meant for one – and living in the midst of 'a hubbub that would wake the dead'.

In August 1872 the family moved briefly to rural Pontoise (north-west of Paris), where Pissarro lived, before setting up home in the nearby village of Auvers-sur-Oise. They stayed there for 18 months before returning to Paris. Later Cézanne settled Hortense and Paul in Marseilles while he continued his itinerant lifestyle, based in Aix and L'Estaque but returning regularly to Paris.

During the period in Auvers, the new sensibility that had emerged in the L'Estaque countryside was strengthened by an intense and more sympathetic artistic involvement with his avant-garde peers, the soon-to-emerge Impressionists, and particularly with Pissarro, who took Cézanne, Monet and Renoir under his wing. In his exquisite drawing *Peasant Girl Wearing a Fichu*, possibly made around 1873 (though some sources date it much later), Cézanne focused on the female form, but with an attention to observed detail and a lightness of touch marked in its contrast to his earlier expressionistic representations of women. The drawing also reveals a capacity to communicate as evocatively through what is not depicted as by what is, through areas of pictorial incompleteness or absence.

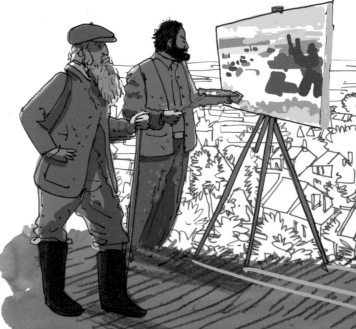

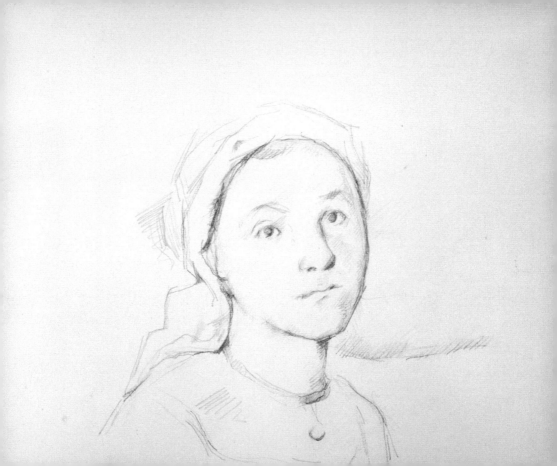

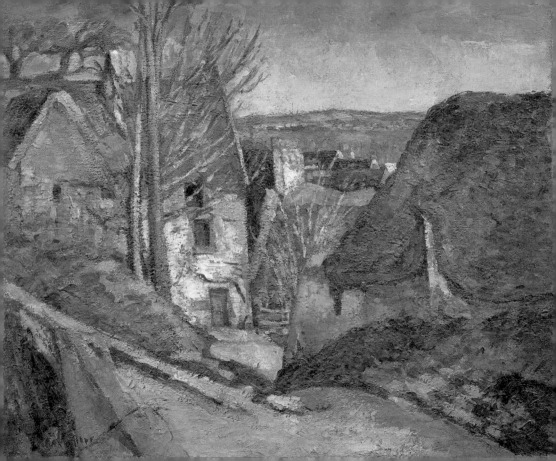

'As for old Pissarro, he was like a father to me.'
Paul Cézanne

Camille Pissarro, like Cézanne, was something of an outsider. Born in the West Indies to a French Jewish father and a mother with Creole origins, he was an anarchist as well as a painter. During the Franco-Prussian War he chose, like Cézanne, to avoid conscription. The relationship between the two men was staunch. Years later, in the 1890s, when Pissarro supported Captain Alfred Dreyfus, a Jew, in his infamous trial for treason, many of Pissarro's friends in the art world turned their backs on him. Cézanne, however, remained a fervent friend and in one of his exhibitions at the time publicly described himself as a pupil of Pissarro.

According to Cézanne, it was thanks to Pissarro in the 1870s that he learned to work consistently and hard. Pissarro helped him achieve his artistic aims through an even greater focus on painting *en plein air* coupled with a new approach to art-making: a noticeable lightening and brightening of his palette and a new, short-stroked mode of applying pigment to canvas. Although Pissarro's *The Public Garden at Pontoise* from 1874 is rather airier than Cézanne's more compressed *The House of the Hanged Man* painted a year earlier, the textured strokes, the colours used, and the view-from-above perspective are comparable. Nonetheless, although Cézanne went on to exhibit with the Impressionists – *The House of the Hanged Man* was shown in the first Impressionist exhibition, held in the photographer Nadar's studio in Paris in 1874 – his love of structure and substance meant that his work never entirely conformed to Impressionism's more ephemeral sensibilities. Also evident in Cézanne's painting – another important feature of his later work – is a challenge to the conventional painterly duality in which linear and colourist approaches to image-making are treated as opposites.

Camille Pissarro
*The Public Garden
at Pontoise*, 1874
Oil on canvas
60 × 73 cm
(23⅝ × 28¾ in)
The Metropolitan Museum
of Art, New York

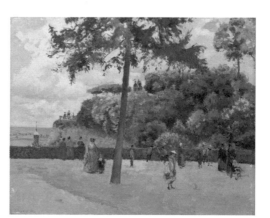

A Modern Olympia

Cézanne created another much-discussed work in 1873, one
that is significantly different from his *House of the Hanged
Man* and other landscape paintings of the period. Apart from
the impressionistic application of paint, it is more akin to the
fantastical, erotic scenes he had started to paint in the 1860s.
The painting in question, *A Modern Olympia* – more of a coloured
sketch – was a visual critique of Manet's *Olympia*, which had
caused such a scandal at the 1865 Salon. Cézanne created his
version while staying in the home of a new friend in Auvers-sur-
Oise, the collector and supporter of the Impressionists Dr Paul
Gachet. In Cézanne's opinion, his own version of *Olympia* was
the more radical: Manet's was not daring enough and showed
insufficient temperament. We can only guess at Manet's response
to this. Notable in Cézanne's version is its wild energy and the
fact that he depicts the bourgeois spectator that is implied by, but
absent from, Manet's painting. He embodies him in the elegantly
attired man – who looks remarkably like Cézanne himself –
ogling the fleshy figure on display before him.

The lumpen rendering of the woman's naked body may have
been inspired by 'A Carrion', a poem from Baudelaire's *Les Fleurs
du Mal* (*The Flowers of Evil*) of 1857 and a lifelong favourite of
Cézanne's. It tells of a dead animal, seen by the side of a path,
'Legs in the air, like a lewd woman, / Burning and sweating
poisons'. Likewise, the painting's fleeting, visual character recalls
further lines from the poem:

> The forms faded, no more than a dream,
> A sketch slowly appearing
> On a forgotten canvas, which the artist finishes
> From memory alone.

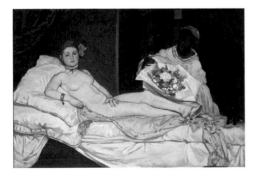

Édouard Manet
Olympia, 1863
Oil on canvas
130 × 190 cm
(51³/₁₆ × 73¹³/₁₆ in)
Musée d'Orsay, Paris

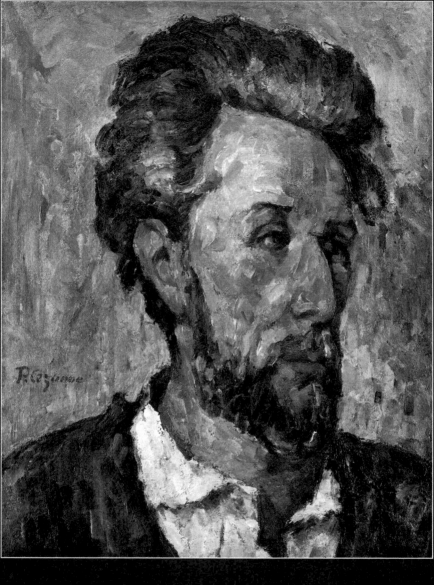

Portrait of Victor Chocquet

Paul Cézanne, 1875

Oil on canvas

45.7 × 36.8 cm (18⅛ × 14¼ in)

Private collection, USA

Discredited

When *A Modern Olympia* was shown at the first Impressionist exhibition in 1874, it met with scorn from the public and critics, as did the exhibition as a whole. His other submissions (including *The House of the Hanged Man*) fared no better. Jean Prouvaire wrote:

> Shall we mention Cézanne who, by the way, has his own legend? No known jury has ever, even in its dreams, imagined the possibility of accepting a single work by this painter, who came to the Salon carrying his paintings on his back, like Jesus Christ carrying his cross.

Three years later Cézanne contributed 16 works to the third Impressionist exhibition, but Pissarro had to fight for their inclusion. Impressionism only achieved critical and public success in the later 1880s and 1890s. Viewers used to the refined art of the Academy disliked the apparently unfinished character of Impressionist canvases and their bright, unvarnished colours. Cézanne's paintings, despite never being entirely in the Impressionist mode, were reviled as ugly and inept.

Nonetheless, Cézanne had a small but growing number of art-world supporters. The critics Théodore Duret and Georges Rivière demonstrated enthusiasm for his work, and there were two collectors, Dr Gachet and a minor government official, Victor Chocquet. Despite his modest means Chocquet was passionate about the work of Renoir and Cézanne and obtained a large number of their paintings. Cézanne painted two portraits of Chocquet between 1876 and 1877. Constructed from dabs of colour, they illuminate his comment that, 'If I paint all the little blues and all the little maroons, I capture and convey his glance.'

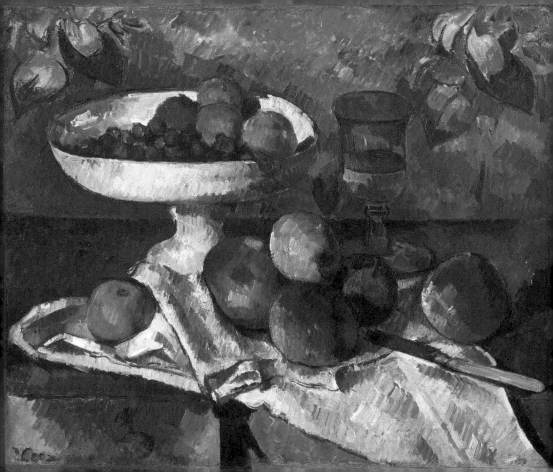

'I should like to astonish Paris with an apple.'
Paul Cézanne

By the later 1870s Impressionist painters had been selling their work to collectors for some years. But, for a variety of individual, ideological, cultural and financial reasons, the group, always diverse, was undergoing a period of disagreement. Degas was furious that certain members still sought approval from the Salon and Cézanne also now distanced himself. Indeed, in June 1880 Zola published an article that described Cézanne as 'having a great painter's temperament still floundering in a search for the right facture, remain[ing] closer to Courbet and Delacroix'. Nonetheless, between 1879 and 1880 Cézanne painted what became one of his most talked-about paintings, *Still Life with Fruit Dish*.

The powerful material presence of this painting indicates a departure from Impressionism, and in it appears one of the motifs most associated with Cézanne: his apples. Some commentators believe that apples had symbolic significance, for instance their biblical association with temptation. Others point out their possible sentimental associations: at school, when Cézanne had sided with Zola against bullies, Zola had given him a basket of apples. What is certain is Cézanne's skill in painting them in their luscious variety: up close, a mass of marks; from further back, each an individual being, seemingly alive, even sentient. Indeed, it was a small 1878 oil study by Cézanne of apples that ignited the avant-garde artists and critics of London's Bloomsbury set, especially Roger Fry, an important advocate of the 'new French painting'. In 1927 Fry reflected at length on Cézanne's 'strong ... feeling for volumes and masses' and on the 'extraordinary repose and equilibrium' in *Still Life with Fruit Dish*.

The painting was first purchased by Paul Gauguin, possibly while he was still working as a stockbroker. He described it as 'an exceptional pearl' and 'the apple of my eye'.

Rediscovering the object

In 'Cézanne's Doubt', an essay on the artist's work and character written in 1945 by Maurice Merleau-Ponty, the French philosopher explained why the Impressionist approach to image-making was formative but not sufficient for Cézanne. Cézanne, he said, wanted to rediscover the object, which the Impressionist focus on atmosphere had caused to dematerialize. While Cézanne still prioritized colour over outline, he wrote, the object is:

> no longer covered by reflections and lost in its relationships to the atmosphere and to other objects; it seems subtly illuminated from within, light emanates from it, and the result is an impression of solidity and material substance.

This new sense of structure and substance may also be seen in this intimate, yet powerful, drawing from around 1880 of Hortense sewing. There is a contrast between the solidity of her body and surroundings and the delicacy of the cloth she is stitching, which is again depicted through absence.

By the time this drawing was made young Paul was eight years old. Two years earlier, in 1878, while Hortense and young Paul were living in Marseilles, Cézanne's father had finally learned of their existence. Furious, he had threatened disinheritance and reduced Cézanne's allowance. Later he relented, and indeed increased it. Cézanne's parents and sisters, and several of his friends, seem never to have taken to Hortense, reputedly because they found her vulgar and avaricious. Nevertheless, she had to care for young Paul on her own while Cézanne continued his itinerant, bachelor-like existence, and with little money, far from her native soil (in the France-Comté region of eastern France). Cézanne adored his son but how he felt about her is unclear. Their relationship endured – Cézanne certainly drew and painted her many times over the years – but their frequent absences from one another seem to imply a lack of closeness or compatibility.

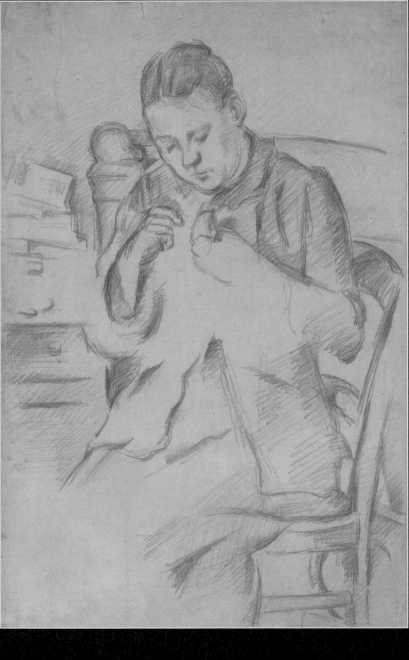

Hortense Fiquet (Madame Cézanne) Sewing
Paul Cézanne, c. 1880

Graphite on paper
47.2 × 30.9 cm (18⁹⁄₁₀ × 12¹⁄₁₀ in)
The Courtauld Gallery, London

'Paris has defeated me.'
Paul Cézanne

Cézanne's painting style matured during the 1880s, but it was a difficult decade for him, both artistically and personally. In 1884 – despite his earlier insistence that he would go on 'hurling' his paintings at the Salon 'for all eternity' – he endured yet another rejection by its jury and finally claimed to have given up on Paris. It cannot have helped that his Impressionist peers, represented by the dealer Durand-Ruel, were now starting to do well.

Then, in 1886, he had a terrible falling out with Zola. Although in the early 1880s Cézanne had stayed regularly with his now successful friend at his beautiful home outside Paris, over the past two decades the boyhood friends had drifted apart. Worse, it seems that Zola was losing faith in Cézanne as an artist. In March 1886 Zola published his novel *L'Œuvre* (*The Masterpiece*). Although Zola insisted that the book's central figure, an unsuccessful and unbalanced painter named Claude Lantier, was meant to represent a generic type of modern artist, not a real person, it seemed evident to many that he was in large part modelled after Cézanne. At the end of the novel Lantier succumbs to his despair at being unable to finish his great masterpiece and commits suicide. Zola and Cézanne were never reconciled. Years later, in 1897, Cézanne opposed Zola's courageous public defence of Alfred Dreyfus in the long drawn-out and socially combustible Dreyfus Affair, on the grounds, he claimed, that Dreyfus was guilty and not the victim of anti-Semitism.

Marriage and a death

During the 1880s Cézanne increasingly withdrew into isolation in Aix, where he continued to be regarded by the locals as an oddity. He did maintain contact with some of his art-world acquaintances and had several sojourns in Paris, paying regular visits to Zola before their rift. But he felt out of place and uncomfortable with Zola, who played host to high-society friends on his large estate. He had also spent six months with Pissarro in Pontoise and in 1883 went on painting excursions with Renoir and Monet in the south of France.

But in 1886, as his relationship with Zola came to an end, Cézanne's personal life also erupted. There were tensions with Hortense – as noted, the couple effectively lived apart and already in 1878 she had absconded for a month to Paris, a city she loved and missed – and in 1885 Cézanne is known to have become romantically infatuated with an unnamed woman from Aix. Then, in April of 1886, under pressure from his mother and sister, and perhaps also his father, Cézanne finally married Hortense, possibly to legitimize the now teenaged young Paul.

Later that year, on 23 October, Cézanne's elderly father died. In the will Cézanne was described by his father as being 'without profession' but, despite earlier threats, Louis-Auguste had not disinherited him. On the contrary, Cézanne and his siblings were well provided for, even wealthy. After the death Cézanne moved back into the Jas de Bouffan with his mother and Marie (Rose being long married). But when Renoir visited Cézanne there in 1888 he soon departed – in a letter to Durand-Ruel he wrote of 'the black avarice that reigns in the household'. It is likely that Hortense and young Paul continued to live separately in Marseilles.

Mont Sainte-Victoire

Despite his troubles, it was in the 1880s that Cézanne painted many of his best-known works. Inspired by his deep immersion in nature, his signature subject Mont Sainte-Victoire, which towered over the Aix landscape, began to take a central place in his paintings. As one of the Inseparables he had explored every aspect of it on foot, and knew all about its geological history and formation. The mountain appears in 44 of his oil paintings and 43 of his watercolours.

Mont Sainte-Victoire with Large Pine of 1887 has been much admired for the way in which Cézanne creates depth and solidity while also collapsing distances. He does this through his use of colour and by causing the pine branches in the foreground seemingly to caress the contours of the distant mountain.

For Cézanne, it was through his relationship with an ancient, geological entity that he declared his modernity and radical approach to depiction. Contrast this with another great – but man-made – triangular icon of French modernity, the Eiffel Tower, then being constructed in the heart of Paris for the 1889 World Fair.

When *Mont Sainte-Victoire with Large Pine* was exhibited in 1895 at a society of amateur artists in Aix, it baffled its audiences but was admired by a young Aixois poet, Joachim Gasquet. The next year Cézanne gifted the painting to him and they became friends.

Mont Sainte-Victoire with Large Pine

Paul Cézanne, 1887

Oil on canvas

66.8 × 92.3 cm (26�5⁄₁₀ × 36⅗⁄₁₀ in)

The Courtauld Gallery, London

Renewed determination

Cézanne was by nature anti-social, so the self-portrait proved an ideal subject for him: there are 26 painted and 24 drawn self-portraits from throughout his lifetime. He generally adopted a pose in which, according to the scholar Hajo Düchting, he is 'turned slightly away, reticent, bitter, misanthropic'. In 1890, the year that marks Cézanne's transition to a mature artistic phase, he painted *Self-Portrait with Palette*. He was 51 years old and, for the last two years, had been living in Paris with Hortense and Paul, in an apartment on the Île Saint-Louis. Cézanne's presence in this work seems heavy and brooding, although the painting's colour scheme is light with touches of warmth. It is a portrait that combines many moods, including, perhaps, one of renewed determination: note the strength and immobility of his pose.

His determination to keep fighting proved worthwhile: official rejection of his work continued, but in other ways the tide was already turning. In November 1889, Cézanne was invited by the art critic Octave Maus to exhibit with Les XX in Brussels. Les XX was a group of 20 Belgian artists who, from 1883 to 1893, held an annual exhibition of their art together with the work of 20 'guest' artists, who included Pissarro, Monet, Gauguin and Van Gogh. Cézanne participated again in 1890. In the last 16 years of his life, his work was shown in Paris and Aix, Berlin, Vienna and London, articles and essays appeared focusing on or referencing his work, and his paintings reached new audiences with each passing year. Another reinvigorating factor was that in 1891, Cézanne renewed his faith, becoming a devout, but not pious, Catholic. This spiritual reconnection seems to have intertwined with his quest for the motif. Reputedly, as the art historian Paul Smith has put it, for Cézanne 'God's presence was visible in the landscape'.

Still wandering

Cézanne continued the pattern of a lifetime, moving from place to place and living apart from his wife and son. When in Aix he stayed at the Jas de Bouffan. He also still made trips to Paris and discovered a new landscape to paint, Fontainebleau, not far from Barbizon and its agricultural landscapes. In 1894 he attended a reception in his honour organized by Monet at Giverny, where he met the sculptor Auguste Rodin and the critic Gustave Geffroy, an important advocate of Cézanne's art who became a friend.

From 1895 Cézanne undertook prolonged excursions around Mont Sainte-Victoire and, at its feet, the disused Bibémus quarries, which had been worked since Roman times. In one of many paintings, dating from around 1895, the quarries' layers of reddish sandstone contrast with the greens of pine trees growing among its deep cracks and crevices. The combination of complex structure, great age and seclusion drew Cézanne in; he felt at home here. Indeed, the rocky scene in this image somewhat recalls his early *Bather and Rocks* (see page 31).

He regarded these places as the true companions of his old age, renting both a cottage and a room in an old country house, the Château Noir near Bibémus, where he stored his painting equipment. The château and its abandoned grounds became a beloved and much-painted location. Over the following years he took various lodgings in the area, since this made painting outside easier. Age was taking its toll and he became unwell. In the late 1870s he contracted what became chronic bronchitis and in 1890 started to suffer from diabetes. On the one hand then, Cézanne was becoming ever more reclusive and itinerant; on the other he single-mindedly established practical living and working conditions that would best serve his art.

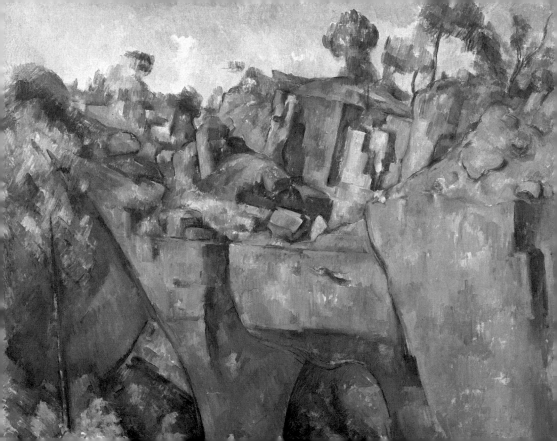

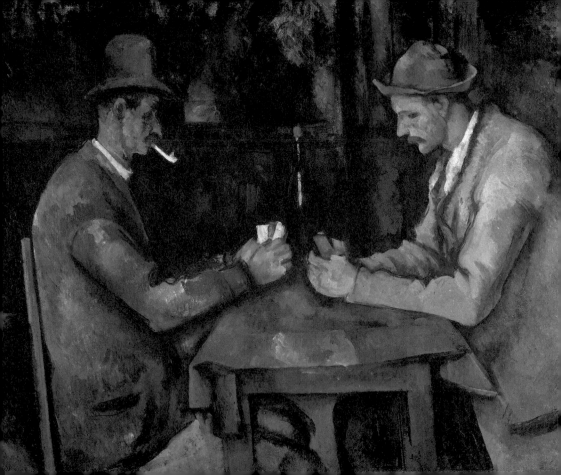

Exploring still life

In his constant quest to depict what might be described as the inner kernel or inner life of things, Cézanne also constructed still-life arrangements. His concern with structure, depth and permanence continued to contrast significantly with the sensibilities of the Impressionists, who were now becoming increasingly popular, though Cézanne greatly admired some of Monet's work. Their focus – whether painting nature, objects or urban life – was on capturing the ephemeral, shifting qualities of light and the sense of impermanence that characterized the fast-moving modern world.

Cézanne's depiction of the enduring and permanent aspects of the world was a time-consuming activity, especially for someone who, though prolific, painted slowly. Still lifes were ideal, stable and robust enough to endure over time – although Cézanne often complained that they, too, frustrated him by rotting: 'Those devilish buggers, they change tone!' He would spend many hours, even days, arranging the objects in question to his taste – pots, statues, baskets, pieces of fruit – often arranged on swatches of cloth, discreetly propped up with coins to keep them stable.

The complexity of Cézanne's completed still lifes caused his admirers, including Gauguin, to puzzle over them. Merleau-Ponty and others have remarked that Cézanne frequently challenged conventional dualities by painting objects as though alive and figures as though inanimate. This is evident in *The Card Players* of 1890–95, in which the two men, the objects, even the atmosphere itself, all seem to be made from the same fundamental material. In addition, Cézanne has created a simple, almost symmetrical pattern of painted white marks – on the men's collars, the pipe, bottle and playing cards – emphasizing further that his human and non-human subjects are part of a single configuration. It is as if the designation of 'still life' is not merely limited to the central portion of the painting where we see a simple bottle of wine poised upon the table's furthest edge: it applies to the image as a whole.

A breakthrough exhibition in Paris

From the early 1870s avant-garde artists including Cézanne, and later Van Gogh, had found an ally in a colour merchant in Paris, known affectionately as Père Tanguy. Tanguy had extended considerable credit to Cézanne in exchange for paintings, which he had put up for sale in his paint shop. In 1894, just one year after the young, anti-establishment art dealer Ambroise Vollard had opened a small, but astutely positioned Paris gallery on rue Laffitte, Père Tanguy died and his collection of paintings was auctioned. Vollard bought four of Cézanne's paintings at a low price, sold them quickly and made a large profit. Vollard was staggered by the lack of public exposure there had been of Cézanne's art and resolved to mount a one-man exhibition. It is possible that his interest in Cézanne was sparked by Renoir, whom he knew. He went to considerable lengths to locate the elusive Cézanne in order to extend his invitation. 'Alas, the task was to find the artist', he wrote in his 1914 book *Cézanne*. He records searching in vain for Cézanne in the forests of Fontainebleau, where he had been told Cézanne had been seen working.

Finally, Vollard made contact with Cézanne by letter and Cézanne, with the help of his son, arranged for 150 works to be despatched to Paris. The exhibition opened in November 1895. Although he no doubt expected it, the press and public at large were dismissive and Cézanne himself stayed away. However, his show did generate great excitement among younger artists in Paris who saw in his works indications as to how they might pursue their own quests for visual and stylistic innovation. Vollard became Cézanne's dealer and Cézanne's artistic fortune began to change.

Thanks to Vollard

It is hard to overestimate Vollard's impact on the Paris art world through his support of the avant-garde, but he effectively pulled Cézanne out of obscurity. Having arrived in Paris in 1887 from the French colony of Réunion in the Indian Ocean, to study law, he soon turned his attention to art instead. He had great commercial flair and was tireless in acquiring, promoting and selling the art he cared about. Arriving just as the Salon system was losing its power and exclusivity, he became one of the nineteenth century's top commercial dealers. He later held flamboyant 'cellar dinners' in his gallery, serving the Creole chicken of his native Réunion to bohemian artists, collectors and dealers. In all, almost 700 of Cézanne's paintings passed through his hands, many of them obtained from Cézanne's son after his death. According to the scholar Alex Danchev, Vollard's 'cunning and astute hoarding were crucial to Cézanne's rise to world-power status'. In other words, Vollard was at once creating a market for Cézanne's work while ensuring he would also be able to meet the demand. Certainly, their careers flourished in tandem.

In around 1899, Cézanne painted a portrait of Vollard. Vollard's reflections on the experience are insightful. Having remarked on Cézanne's often slow and painful progress, Vollard recalls pointing out to Cézanne two small patches on his hand where the canvas was not covered. Cézanne responded that: 'I may be able to find the right colour with which to fill those blank patches. But understand a little, Monsieur Vollard, if I put something there at random, I would be forced to begin my painting again, starting from that point.'

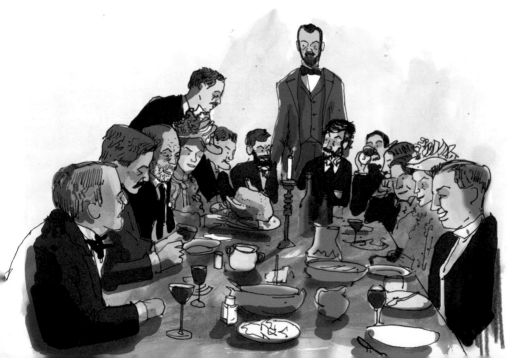

Portrait of Ambroise Vollard
Paul Cézanne, 1899

Oil on canvas
100 × 81 cm (39⅜ × 31⅞ in)
Petit Palais, Musée des Beaux-Arts de la Ville de Paris

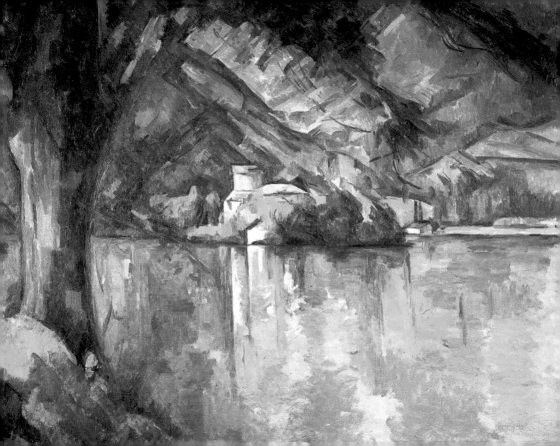

Balance, harmony and stability ... in paint

Although he was now receiving recognition, the aging Cézanne became increasingly reclusive, combustible and often rude – even about his friends, Pissarro, Monet and Renoir. He was suspicious of others, wary, as he reportedly put it, of 'people getting their hooks into him'. But during the last years of his life, his complex, multifaceted paintings conveyed balance, harmony and stability. This was often supported by his choice of subjects: the stable triangularity of his beloved Mont Sainte-Victoire or, as here, the calm, glassy 'Blue Lake' at Annecy in the Savoy Alps. He went there to paint in 1896 but also to recuperate after a bout of bad health. Even in his paintings of riotously assembled objects, as Roger Fry said of *Still Life with Fruit Dish* (see page 42):

> One divines, in fact, that the forms are held together by some strict harmonic principle almost like that of the canon in Greek architecture, and that it is this that gives the extraordinary repose and equilibrium to the whole design.

The Blue Lake is imbued with this sensibility, seeming to hover on the edge of timelessness as the painter waits for the unifying motif of the lake to reveal itself. It also reveals Cézanne's approach to image-making: he applied patches of colour to all parts of the canvas at once, carefully considering the placement of his marks, knowing that each one would alter the overall balance. As the critic John Berger has recently put it, Cézanne's painted surfaces of complex, substantial colours, 'are like woven fabric except that, instead of being made from thread or cotton, they are made from the traces a paintbrush or palette knife leaves in oil paint'. These traces of colour, he continues, are applied 'not where they correspond to the local colour of an object, but where they can indicate a path for our eyes through space, receding or oncoming'.

Farewell to Jas de Bouffan

In June 1897, having spent a little time in Paris, Cézanne moved back to Aix in order to further explore the Bibémus quarries. Within months, his mother died at the age of 82. His sister Marie now ran the household at Jas de Bouffan and quarrels began over the inheritance. He returned to the capital in May of 1898 for his second solo exhibition at Vollard's gallery. Then, in the autumn of 1899, he finally returned to Aix where he remained, more or less continually, until his death. However, in November the Jas de Bouffan was sold and, while clearing the house, Cézanne built a great bonfire and, it is thought, destroyed a good many of his early works. After Cézanne's death, the new owner, Louis Granel, proposed having Cézanne's mural, *The Four Seasons*, removed from the wall and given to the Luxembourg Museum in Paris, but the museum's director turned this offer down, claiming that the work neither represented nor honoured Cézanne. The murals are now in the Petit Palais museum in Paris.

Having lost the Jas de Bouffan, Cézanne hoped to purchase the Château Noir. When this fell through, he moved to an apartment on rue Boulegon in Aix. Hortense and young Paul, who was now in his late twenties, were living comfortably in Paris, where, in 1899, Cézanne was exhibiting once again. He had one show at the Salon des Indépendants, which had been established in 1884 by the painters Odilon Redon, Paul Signac and others. Like Cézanne, they had exhibited with the Impressionists but were now developing along more stylized routes. Cézanne also had a second exhibition at Vollard's gallery. It is likely that his son and perhaps also his wife attended these exhibitions: by this time young Paul, and at times also Hortense, who were still financially supported by the reclusive Cézanne, in turn frequently supported him by acting as his agents.

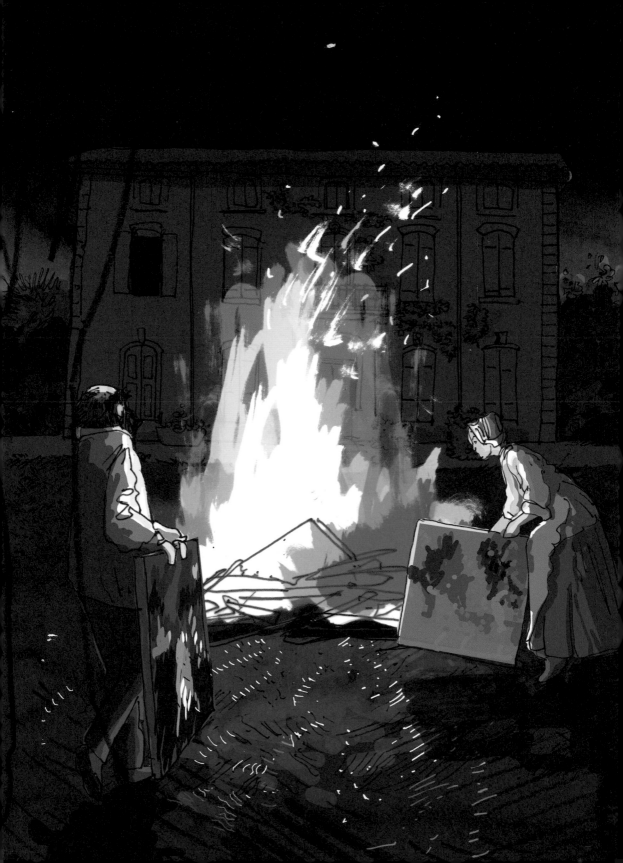

Homage in Paris

By 1900, aged 61, Cézanne was widely recognized and appreciated in the avant-garde art world. So much so that the young painter Maurice Denis, a long-time admirer, painted his *Homage to Cézanne*. The rather sombre painting, set in Vollard's gallery, has as its focus none other than Cézanne's *Still Life with Fruit Dish*, once owned by Gauguin. The admirers gathered around it are mainly Symbolist painters from the Nabis group – *nabi* means 'prophet' in Hebrew – founded by Denis and other students at the academic art school, the Académie Julian, around 1888. The prophetic was important in Symbolism, a movement in both art and poetry that, unlike Impressionism, was anti-realist, favouring the imaginative, the dreamlike and the spiritual. It was strongly influenced by the work of Gauguin, who was in turn greatly inspired by Cézanne – indeed, one of Gauguin's paintings is partially visible in the background, hanging on the gallery wall. Symbolist artists were ardently drawn to Cézanne's art, perceiving within it openings into the deep life of the spirit that they also sought.

The absence of Cézanne himself from the composition is perhaps out of respect for his desire to remain at arm's length from the Paris art scene. If the reminiscences of Gasquet are accurate, Cézanne had at one point asserted that he 'thought one could do a good painting without attracting attention to one's private life – certainly an artist wishes to raise himself intellectually as much as possible, but the man must remain obscure'. This marks a definite shift in perspective from his attempts, as a young painter, to assault the Paris art world with his personality as well as his paintings. Cézanne wrote to thank Denis for this tribute, to which Denis responded:

> Perhaps you will now have some idea of the place you occupy in the painting of our time, of the admiration you inspire, and of the enlightening enthusiasm of a few young people, myself included, who can rightly call themselves your students.

Maurice Denis
Homage to Cézanne (detail), 1900
Oil on canvas
180 × 240 cm (70⅞ × 94½ in)
Musée d'Orsay, Paris

Odilon Redon

A leading Symbolist artist. Older than the others, Redon was already a supporter of Cézanne, but here it looks as though he is seeing this painting for the first time.

Édouard Vuillard

A member of the Nabis group, Vuillard shared a studio with Bonnard and Denis.

André Mellerio

A writer who published a book on Redon in 1923.

Ambroise Vollard

Stands a head and shoulders above the rest, holding onto and peering out from behind the easel.

Maurice Denis

A co-founder of the Nabis at the age of 18, he was also known as a prolific writer and critic. A strong sense of the rhythmic and decorative is evident in his *Homage to Cézanne*.

Paul Sérusier

The pioneering abstract painter who so inspired the Nabis and who co-founded the group with Denis. He is in full flow, enthusing about Cézanne's painting to Redon.

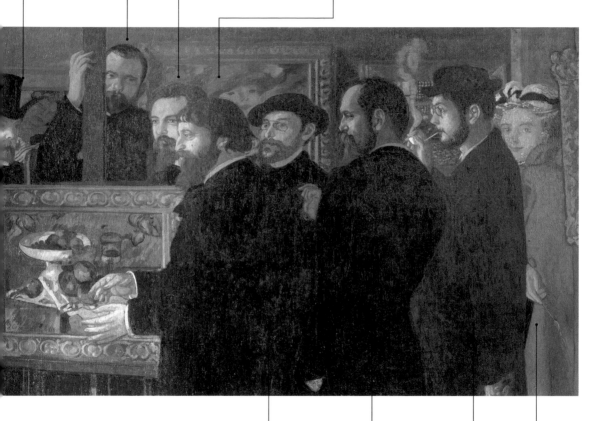

Paul Ranson

A painter in the Nabis group, Ranson trained as a decorative artist before meeting Sérusier at the Académie Julian. On Saturdays the Nabis met in his studio.

Ker-Xavier Roussel

Another member of the Nabis. Although enrolled in the École des Beaux-Arts in 1888, he also began to attend the Académie Julian where he met Denis and the others.

Pierre Bonnard

An Impressionist painter whose works, like those of the Symbolists, tended strongly towards the decorative.

Marthe Denis

The wife of Maurice looks on from the sidelines.

With Mont Sainte-Victoire visible to the east, Cézanne frequently painted outside the studio, both on the terrace and in the surrounding grounds.

The new studio at Les Lauves

In November 1901 Cézanne bought land along the Lauves road outside Aix in order to build a studio. Initially he was furious with the new building, describing it as 'a weird villa, with a cut-out roof and a wooden balcony'. He promptly had all its extraneous features removed. By September 1902 the studio was complete. In January 1903 Cézanne wrote to Vollard informing him of this new development: 'I have a big studio in the country,' he wrote, 'I work there, I feel better there than in town. I have made some progress. Why so late, and with such difficulty?'

Cézanne produced numerous still-life paintings in the studio on the upper floor, and, most famously, his large paintings of bathers (see page 73).

Aix as a place of pilgrimage

As we have seen, since Cézanne's 1895 exhibition at Vollard's gallery, his influence had grown within what would later be called 'post-Impressionist' avant-garde circles (he, too, later became known as a post-Impressionist). He was also more widely known in Paris, where, in 1900, three of his paintings were exhibited at the World Fair.

In the last years of his life, Cézanne rarely left Aix. Those artists, dealers and collectors who recognized his importance knew they had to go to him, so, in the early part of the twentieth century, a number of art-world pilgrimages were made to Aix. One of the first to visit him, late in 1901, was a young artist called Charles Camoin, a student at the Académie Julian with Henri Matisse and Georges Rouault. In 1904 he returned with Émile Bernard, a young painter and decorative artist. Bernard became one of Cézanne's most frequent visitors and his best-known interlocutor. Cézanne's work was still largely misunderstood and commonly described, even by his admirers, as difficult, so he was keen to disseminate his ideas: both face to face and in letters, Cézanne expounded his views on art to Bernard, who published the letters and his recollections in his *Souvenirs* of 1907. Bernard also made photographs of Cézanne at work.

Vollard visited several times, including in 1902 when he told a sorrowful Cézanne of the death of Zola. Poet and critic Léo Larguier also came, as did Durand-Ruel, who was by now buying Cézanne's work, and another famous Paris art dealer, Gaston Bernheim-Jeune. In 1906, the last year of his life, Cézanne was visited by the German collector Karl Ernst Osthaus, who bought two paintings for the Folkwang Museum which he had founded in Hagen to promote the new French painting.

Despite Cézanne's habitual irritability and suspicion, he is known to have welcomed his young visitors in particular, and to have had a strong inclination to mentor and encourage them.

Tribute

From October to November 1904 Cézanne was again honoured in Paris. Thirty-one of his paintings and two drawings were shown at the new Salon d'Automne (Autumn Salon) in Paris. This major, annual exhibition, held at the Petit Palais, had been established just a year earlier at the instigation of Frantz Jourdain, the Belgian man of letters, art enthusiast and president of the Union of Art Criticism. The aim of the Salon was to exhibit the work of contemporary artists and to popularize the new French art. Cézanne was given his own room. The exhibition was the first really prestigious, public showing of his work and made it available to a much wider audience (and his work was also exhibited there in the following two years). Also in 1904, the philosopher Ernst Cassirer, whose interests spanned mathematics, the natural sciences, the humanities and the arts, organized a solo exhibition of Cézanne's work in Berlin.

The works shown at the Salon were selected mainly by Vollard. Paul, Cézanne's son, sent him a letter of thanks: 'My father is enchanted with his success at the Salon d'Automne and owes you heartfelt thanks for the care you took with his exhibition.' One of the display strategies that Vollard had devised for showing work was that of hanging framed panels above the selected paintings containing small photographic reproductions of related works not in the exhibition.

The last great masterworks: *The Large Bathers*

Cézanne's bathers, which he started drawing and painting in earnest in the mid-1870s, were as important to him as his apples and mountain. They were also greatly admired by his fellow artists: in 1899, for instance, the great modern colourist Matisse saw a composition of three bathers that Cézanne had painted between 1879 and 1882. Vollard let the impoverished Matisse acquire the painting by signing a promissory note, which he repaid in instalments. When an elderly Matisse donated the work to the Petit Palais museum in 1936, he wrote to the curator:

> In the thirty-seven years I have owned this canvas, I have come to know it quite well, though not entirely, I hope; it has sustained me morally in the critical moments of my venture as an artist; I have drawn from it my faith and my perseverance; for this reason, allow me to request that it be placed so that it may be seen to its best advantage. ... please accept these remarks as the excusable testimony of my admiration for this work which has grown increasingly greater ever since I have owned it.

In the years preceding his death, Cézanne worked on the monumental *Large Bathers* series. In 1904, Bernard photographed Cézanne at Les Lauves in front of one on which he had been working since 1894. The *Large Bathers* are profoundly moving works because they depict harmony: gently moving, solid bodies, human and natural, lean towards one another. They communicate Cézanne's enduring love of nature, and recall, perhaps, the harmony of human companionship he experienced as one of the Inseparables. They are also profoundly puzzling works, uncomfortable at first for eyes and minds used to narrow ideas of female beauty, for instance, or conventional ideas about composition. They demand as much viewing time as they took to paint.

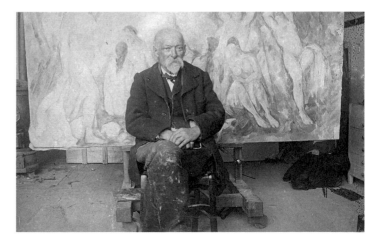

Cézanne in front of *The Large Bathers* (version now in the National Gallery, London) at Les Lauves, 1904.

Photographed by Émile Bernard. National Gallery of Art, Washington, Gallery Archives, Rewald Papers.

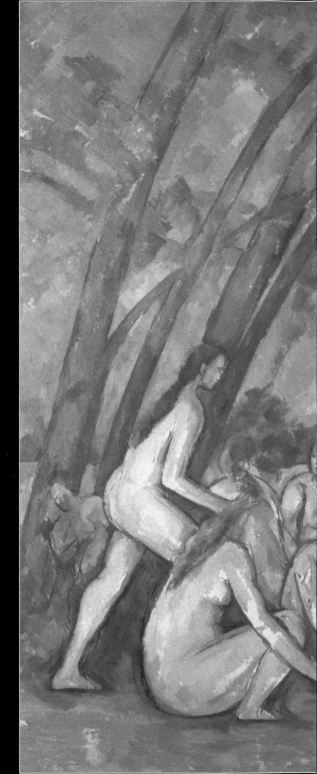

The Large Bathers
Paul Cézanne, 1906

Oil on canvas
0.5 × 250.8 cm (82⅞ × 98¾ in)
Philadelphia Museum of Art.
Purchased with the
W.P. Wilstach Fund,
1937, W1937-1-1

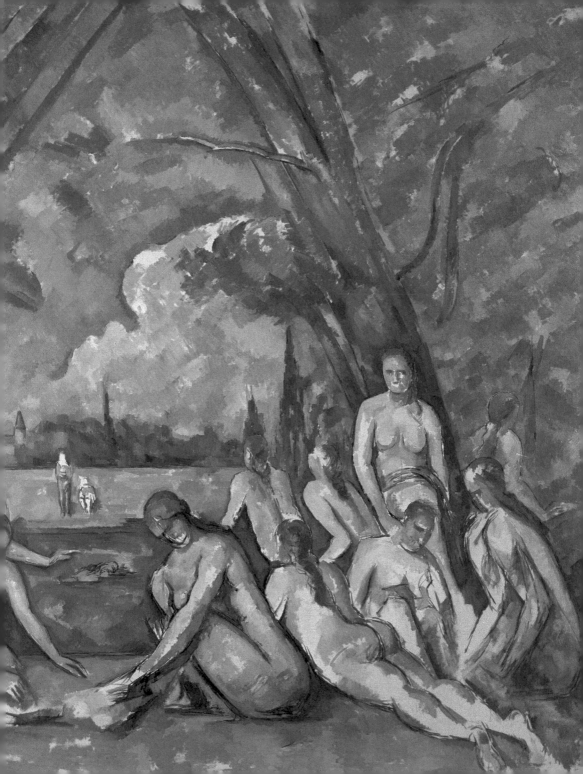

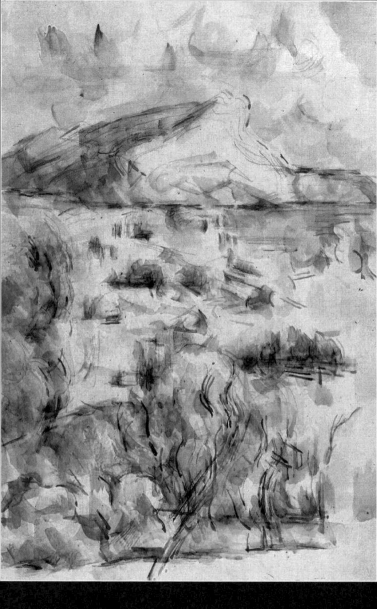

Mont Sainte-Victoire
seen from Les Lauves
Paul Cézanne, 1901–06

Watercolour and pencil on paper
48 × 31 cm (18⅞ × 12¼ in)

The late watercolours

In the last years of his life, Cézanne painted many watercolours – mainly landscapes, *en plein air*, and still lifes in the studio – for which Vollard organized a special exhibition at his gallery in 1905.

At first sight, this watercolour of Mont Sainte-Victoire, painted between 1901 and 1906, seems the inverse of his oil paintings of the same motif: it is open and ephemeral, where the oil paintings convey layer upon layer of substance, volume and depth. When observed more closely though, it becomes clear that in this image there is deep structure and coherence. It is significant that Cézanne, though old and ill, could create images that are so extraordinarily alive. They embody an energy that is much more subtle than that of the early, wild and expressionistic paintings, but it is discernible nonetheless. The watercolours also did something that Cézanne felt his paintings did not: they conveyed luminosity, a quality that was greatly important to him.

The watercolours clearly reveal how they have been made. On his 1904 visit to Cézanne, Bernard observed the artist at work on a watercolour of Mont Sainte-Victoire:

> His method was strange, entirely different from the usual practices and of an extreme complexity. He began with the shadows and with a touch, which he covered with a second more extensive touch, then with a third, until all these tints, forming a mesh, both coloured and modelled the object.

In the watercolours, Cézanne also had to negotiate the relationship between painting and drawing, trying to get the balance right between them. When these paintings are studied, it is evident that, instead of sketching in pencil first and then filling in with colour, he worked, as he did in his oil paintings, in an open-ended, all-over manner, moving between each medium as the image developed.

'I want to die painting.'
Paul Cézanne

In his last letter to Bernard, written on 21 September 1906, Cézanne asked a question that illuminates his questing nature and commitment to keep striving as an artist. 'Will I reach the goal so long sought after, so long pursued,' he wrote, '... having realized something more developed than in the past, and thereby proving the theories?' Just over a month later, on 23 October 1906, at the age of 67, Cézanne died. Some days previously, having misjudged the weather, he had been caught in a storm while painting. On his way home he collapsed by the roadside. He was found and taken home in a cart. The next day he went out again and this time worked on a portrait of Vallier, the gardener at Les Lauves, whom he had already painted a number of times. Cézanne returned home seriously ill with pneumonia. His housekeeper wrote to Hortense and young Paul in Paris, urging them to return, but they arrived too late. At the 1906 Salon d'Automne, where ten of his paintings were being exhibited, black crêpe was attached to his name in the exhibition room to mark his death.

Cézanne did indeed die painting as he had once wished, industrious to the end. And his final paintings were sublime. In this portrait of Vallier – not the final portrait, but one probably from the summer and autumn of 1906 – he seems to have achieved the luminosity he sought. As in all his mature work, in those broad, overlapping dabs of oil paint, Cézanne captured and made coherent many subtly shifting viewpoints. This approach particularly influenced Pablo Picasso and Georges Braque as they laboured, during this first decade of the twentieth century, towards their soon-to-emerge Cubist paintings.

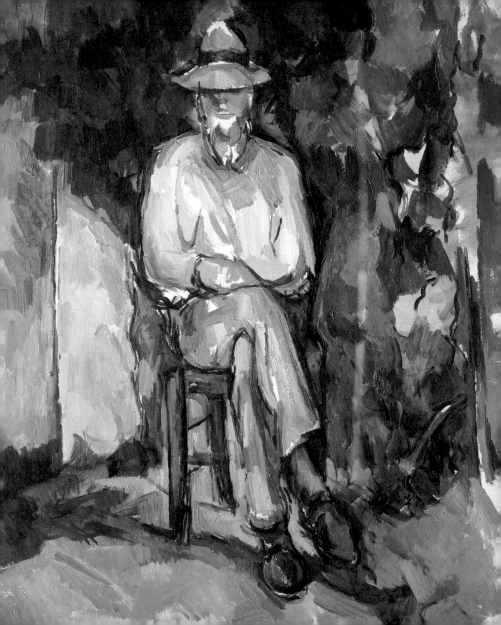

After the master's death, I follow traces of him everywhere.
Rainer Maria Rilke

Following his death, a massive retrospective of Cézanne's work was held at the 1907 Salon d'Automne, which has been described as 'the most consequential exhibition of modern times'. It had an impact not only on artists but also on poets and thinkers. Cézanne's art offered vision, as well as specific visual and technical possibilities, to painters of many different inclinations. What seems to have been particularly significant, however, was that his work presented itself not as something to be emulated, but as a provocation. To paraphrase Merleau-Ponty, it seemed to act as an inspirational force, a catalyst to others to pursue 'that which was most their own'. Cézanne's life story – that is, his determination to keep painting his way, no matter what were the inner or outer obstacles – must also have encouraged many. In Braque's words, 'Cézanne swept away the idea of mastery in painting; he gave a taste for risk.'

Today Cézanne is an artist who has long been considered one of the 'fathers' of modern art (if not *the* father). His work has become familiar and less challenging to contemporary taste than it once was. But it has not become domesticated; it still undeniably has temperament, guts even. It does not simply hand itself over to us but demands our prolonged attention and our tenacity.

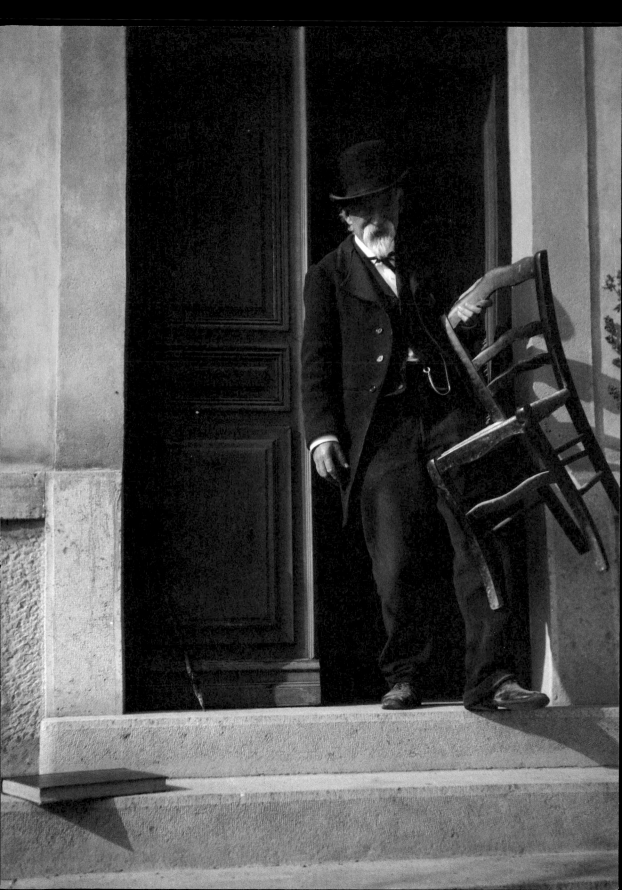

Acknowledgements

Working on this book has been a joyful collaborative experience. My thanks go to Catherine Ingram for inviting me in, to Donald Dinwiddie, Felicity Awdry, Alex Coco, Julia Ruxton and Felicity Maunder at Laurence King, and to Patrick Vale for his wonderful illustrations.

Bibliography

Ruth Butler, *Hidden in the Shadow of the Master: The Model-Wives of Cézanne, Monet, and Rodin* (Yale University Press, 2008)

Françoise Cachin and Joseph Rishel, *Cézanne* (exh. cat., Galeries nationales du Grand Palais, Paris, Tate Gallery, London, and Philadelphia Museum of Art; Harry N. Abrams, 1996)

Alex Danchev, *Cézanne: A Life* (Profile Books, 2012)

Hajo Düchting, *Paul Cézanne: Nature into Art* (Taschen, 2003)

Roger Fry, *Cézanne: A Study of his Development* [1927], 2nd edn (Hogarth Press, 1952)

Patricia Mainardi, *The End of the Salon: Art and State in the Early Third Republic* (Cambridge University Press, 1994)

Joachim Pissarro, *Cézanne and Pissarro: Pioneering Modern Painting, 1865–1885* (exh. cat., Museum of Modern Art, New York, 2005)

Steven Platzman, *Cézanne: The Self-Portraits* (University of California Press/Thames & Hudson, 2001)

Rebecca Rabinow *et al.*, eds, *Cézanne to Picasso: Ambroise Vollard, Patron of the Avant-Garde* (exh. cat., Metropolitan Museum of Art, New York, 2006)

Paul Smith, *Interpreting Cézanne* (Tate Publishing, 1996)

Jorella Andrews

Jorella Andrews is a senior lecturer in the Visual Cultures department at Goldsmiths, University of London. Having trained as a fine artist and then as an art theorist, she is interested in the relations between philosophy, perception and art practice. She is the author of *Showing Off! A Philosophy of Image* (Bloomsbury, 2014) and the series editor for 'Visual Culture As', the first three titles of which have been published by Sternberg Press (2013).

Patrick Vale

Patrick Vale is an internationally recognized illustrator best known for his work based on cities and architecture. Among his recent projects has been his time-lapsed film, 'Empire State of Pen'. He lives and works in London.

Picture credits

All illustrations by Patrick Vale.

18 Musée d'Orsay, Paris, France/ Giraudon/Bridgeman Images **19** De Agostini Picture Library/Scala, Florence **28** Photograph © The State Hermitage Museum/photo by Vladimir Terebenin, Leonard Kheifets, Yuri Molodkovets **31** Erich Lessing/akg-images **32** Photo National Gallery of Art, Washington D.C. **35** Philadelphia Museum of Art, Pennsylvania, PA, USA/The Henry P. McIlhenny Collection in Memory of Frances P. McIlhenny, 1986/Bridgeman Images **36** © Photo Josse, Paris **37** Image copyright The Metropolitan Museum of Art/Art Resource/Scala, Florence **38 and 39** © Photo Josse, Paris **40** © PAINTING/ Alamy **42** Digital image, The Museum of Modern Art, New York/Scala, Florence **45 and 49** © Samuel Courtauld Trust, The Courtauld Gallery, London, UK/ Bridgeman Images **50** Erich Lessing/De Agostini Picture Library/Getty Images **53** © Peter Willi/Artothek **54** Album/ Oronoz/akg-images **59** akg-images **60** © Samuel Courtauld Trust, The Courtauld Gallery, London, UK/Bridgeman Images **64–65** White Images/Scala, Florence **72–73** Philadelphia Museum of Art, Pennsylvania, PA, USA/Bridgeman Images **74** Private collection/Bridgeman Images **77** M. Carrieri/De Agostini Picture Library/Getty Images **79** Foto Marburg, reg.no. 610-620